F
548.52
.S76
2005

LEG

Chicago Public Library

W9-BBS-375

On city streets : Chicago. 1964-2004

ON CITY STREETS

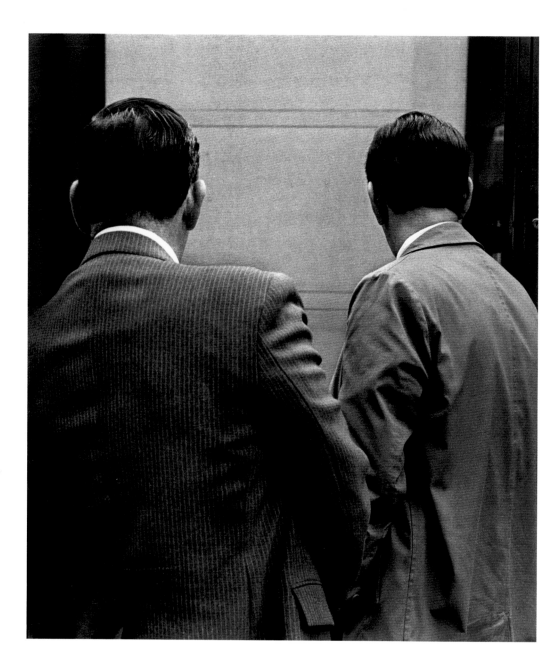

ON CITY STREETS
Chicago, 1964–2004

BY GARY STOCHL

WITH AN INTRODUCTION BY BOB THALL

Chicago Public Library
Legler Branch
115 So. Pulaski 60624

Center for American Places
Santa Fe, New Mexico,
and Staunton, Virginia

in association with
Columbia College Chicago

PUBLISHER'S NOTES: *On City Streets: Chicago, 1964–2004* is the sixth volume in the series *Center Books on Chicago and Environs*, created and directed by the Center for American Places, with the generous financial assistance of the Graham Foundation for Advanced Studies in the Fine Arts. This book was brought to publication in an edition of 2,200 softbound copies with the generous support of Jeanne and Richard S. Press, Columbia College Chicago, and the Friends of the Center for American Places, for which the publisher is most grateful. For more information about the Center for American Places and the publication of *On City Streets: Chicago, 1964–2004*, please see pages 62–63.

Copyright © 2005 Center for American Places
Photographs copyright © 2005 Gary Stochl
All rights reserved
Published 2005. First edition.
Printed by Oddi Printing Ltd., Reykjavik, Iceland, on acid-free paper.

Design by Colleen Plumb
www.colleenplumb.com

Center for American Places, Inc.
P.O. Box 23225
Santa Fe, New Mexico 87502, U.S.A.
www.americanplaces.org

Distributed by the University of Chicago Press
www.press.uchicago.edu

9 8 7 6 5 4 3 2 1

Library of Congress Cataloging-in-Publication Data
is available from the publisher upon request.

ISBN 1-930066-37-6

Frontispiece: The Loop, 1986

R07173 84234

Chicago Public Library
Legler Branch
115 So. Pulaski 60624

CONTENTS

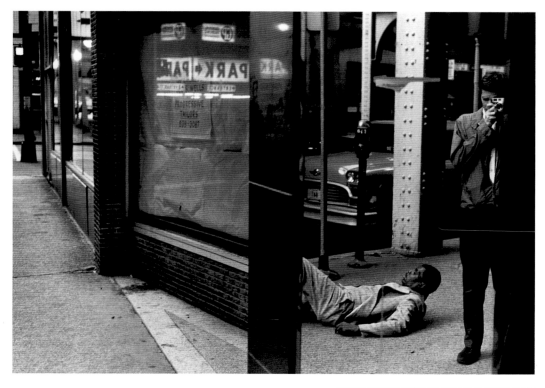

Self-Portrait with Stranger, Van Buren Street, 1978

INTRODUCTION
by Bob Thall

"What a great story." That's what everyone says when I tell them about Gary Stochl and his work. It *is* a great story, at once both uplifting and perplexing. Stochl's narrative is one of long-term commitment, ambition, talent, and an intensely personal vision. It's also a tale of isolation, which forces us to question our assumptions about how American artists, working today, are generally entangled in the complex web of the artistic community: schools, museums, galleries, funders, dealers, curators, critics, collectors, and publishers. What happens to an artist when he or she has no contact with that artistic community? Is it possible to be a serious artist without those connections—and what happens to the work of an isolated artist?

In late Spring 2004, I returned to my office in the Photography Department at Columbia College Chicago to find a cluster of students waiting for the department's academic advisor. There was also an older fellow, about my age, sitting there with a paper shopping bag. Our secretary looked at me with a troubled expression, nodded at him, and said, "Uh, Bob, this gentleman wants to show someone some photographs." I was busy, but I invited him into my office. I thought he was a returning student, perhaps an Art/Design major who wanted to place out of his photography requirement. I thought I could handle this matter quickly.

Gary Stochl sat down and told me, no, he wasn't interested in taking any classes—that wasn't why he was here. "No?" I asked.

"No, I've been doing photography for forty years and really haven't shown my work to anyone. I thought it was time I started to do that. You're a Photography Department, so I thought I'd come here." He reached into the bag and pulled out a stack of loose prints perhaps eight inches high. Uh-oh, I thought, this is going to mess up my afternoon. "Listen," I said, "I have a meeting in just a few minutes, but I'll be happy to take a fast look at these before I have to go."

I started to flip quickly through the photographs. Stochl told me later that he was shocked at how little time I spent with those first ones. Well, I didn't expect much. But, after about fifteen or twenty images, I had the odd feeling that this strange, chance meeting might be something exceptional, so I slowed down a bit. After another ten or twenty prints, I was no longer hurrying through his work. I'd forgotten about my fictitious meeting, and I'd also forgotten about all of the very real things I had to do that afternoon. Out of the 300 or so photographs I saw that first day, all of them were accomplished, serious images that consistently pursued a sophisticated visual and emotional agenda. Perhaps half the photographs were really excellent, and, of those, fifty or so were the kind of memorable, extraordinary images that notable photographers build their careers on. These pictures were reminiscent of iconic images that one expects to see in history of photography books. One didn't expect to see them pop out of a shopping bag at a chance meeting.

I spent two hours with Stochl that first day. My colleagues Dawoud Bey and Greg Foster-Rice walked by, and I called them in

to meet Stochl and see his work. Like me, they were stunned by the photographs. We tried to give him a crash course in getting his work out, covering topics such as editing and presentation. Finally, we asked him to do a preliminary selection and meet with us again. At the second meeting, we worked with him to edit a tight, representative sample. We thought he needed to pare the large stack of photographs down to a number that a curator or dealer could accommodate on first viewing. It was hard work. There were simply too many extraordinary images, and it was difficult to get down to a reasonably sized set of photographs.

It was clear that Gary Stochl's work was significant, and it was important that his photographs be known and have a public life in the photographic medium. As part of the Chicago photographic community, it was appropriate that the Photography Department of Columbia College Chicago help. We matted some of the work and then made some calls to arrange introductions. Of the many people who took the time to see Stochl's work, the open-mindedness, enthusiasm, and generosity of David Travis, Liz Siegel, and Kate Bussard at the Art Institute of Chicago, photography dealer Shashi Caudill, collector Dick Press, and Gregory Knight at the Chicago Cultural Center especially impressed me. I was also struck by how quickly Gary Stochl learned the ropes, jump-starting a career that had been silent forty years.

Two great traditions in modern American photography particularly interest me. One might be called "Personal Documentary." This strain of photography begins with Walker Evans, but the best example, perhaps, is the work of Robert Frank. Rather than describe a generally understood subject (a neighborhood, an event, a clearly delineated social situation or problem), Robert Frank

sought out the circumstances—the places, people, events, and moments—that conformed to his positions on America. Photographers in Frank's tradition may make highly descriptive and objective-looking images, but the real point is to collect evidence to support their views of life, no matter how subjective.

The tradition that counterweights, even opposes, this passionate advocacy of a subjective view of life is "Modernist Formalism," a strain of photography that was particularly strong at the Institute of Design (ID) in Chicago, when the photography program flourished under the guidance of Harry Callahan and Aaron Siskind. Of the many notable ID students, Ray K. Metzger is a great example of this type of photographer. His work, like that of other photographers within this tradition, pursues serious investigations into the nature of the photographic medium. ID terms such as "camera vision" and "picture space" indicate an interest in the reality of the photograph, independent of the "real" world. These photographs teach us about the photographic medium, and, perhaps more importantly, these photographs make us conscious of our own process of perception and how we see (or ignore) the visual world.

Many photographers working in Chicago have pursued either an intensely personal viewpoint or provocative, formalist work. Both traditions are worthwhile and challenging, but very few photographers anywhere ambitiously pursue both tracks at once. It's always difficult to reveal successfully an intensely personal and consistent view of life while integrating a sophisticated agenda of formal experiments and innovations. For the few who do try to combine these traditions, the photographic success rate is understandably low: lots of strikeouts, a hit every so often, and rarely a home run. What was so astonishing about seeing those

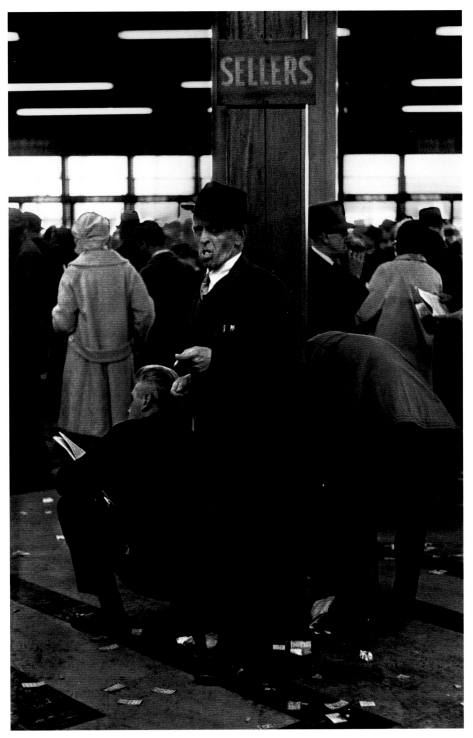

Sportsman's Park, 1964

first stacks of Stochl's photographs was that, although he was consciously trying to accomplish this difficult balancing act, the normal odds didn't seem to apply to him. He hit it out of the park over and over again.

Gary Stochl first saw the photographs of Henri Cartier-Bresson (and, later, Robert Frank) in the 1960s and was inspired to buy a Leica camera to begin photographing. Frank's influence is clear in Stochl's work, but while Frank's photographs express a political and social reaction to an entire nation, Stochl's photographs of life on the streets of Chicago deal with the texture and drama of single lives. Stochl visually describes ordinary people as individuals, not as examples of American stereotypes. He photographs a diverse range of Chicagoans with an alert exactness that is neither flattering nor unkind.

Gary Stochl's photographs rarely contain the dramatic moments or the weird, ironic juxtapositions that often attract street photographers. Instead, with unnerving directness and consistency, Stochl's photographs present people who seem to struggle with the difficulty and loneliness of normal everyday life. The honesty and grimness of the images can at times be disturbing and, like all good art, leave the viewer with an altered sense of the world. From the first photographs he made in the 1960s to photographs he made last month, Stochl's images present a consistently tough-minded and dark view of life.

Simultaneously, his photographs also pursue a program of visual experimentation with remarkable skill, intelligence, and patience. Stochl often constructs complex photographs in which the frame is split into two or three sections, each with subtly different, but crucially interconnected content. In other photographs, reflections, openings in walls, barriers, and other

elements not only separate the people photographed, but also relate them to the larger urban landscape. In some images, implausible coincidences of tone and gesture are used to reveal subtle and important content. Exquisite moments of light and shadow are often employed in the photographs to create a dramatic stage set for ordinary life in a major American city.

These are remarkably sophisticated photographic strategies. Looking through hundreds of Stochl's photographs, one sees a photographer investigating these visual ideas in an organized, persistent manner, even as he responds intuitively to the emotional content of life around him. It's an amazing combination.

It is astonishing that Gary Stochl has photographed intensively for forty years, and continues to work at an admirable pace, without any of the normal support and encouragement artists

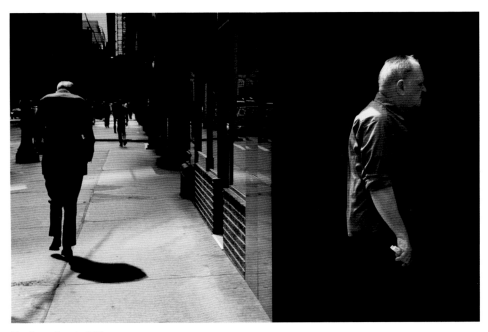

Van Buren Street, 1980

typically seek and enjoy. Compare my career to Stochl's experience as a photographer. I had wonderful teachers who were sophisticated and supportive. I studied with many other young photographers who became friends, competitors, and resources. I've received grants, fellowships, and commissions that supported my work. Curators, dealers, editors, and publishers have been generous with their long-term interest in my photography and provided opportunities for exhibitions and publications. Critics and collectors have provided me with feedback and support. I've had a teaching position that not only pays my bills, but also generates an automatic community of photographers that stimulates me to work and forms a constant and immediate audience for my new photographic work. I've been lucky and yet, I admit, at times I've found it difficult to keep working ambitiously as a photographer. It's hard to keep going for decades upon decades. I've sometimes gotten lazy, confused, or discouraged. Despite my good luck and advantages, I've never found it easy.

Gary Stochl had none of the kind of support and encouragement I had: no teachers, no exhibitions until his first show in Fall 2003, no community of like-minded photographers, no dealer, no sales, no commissions, no publications, no reviews, no grants, and no job in the field. Nothing. Absolutely nothing for almost forty years. And yet he's consistently worked with astounding dedication, self-discipline, and ambition, all bedrocks of the creative process.

Like all great stories, this one holds some lessons. Gary Stochl's long journey should re-teach us the importance of devotion, perseverance, and personal vision. His story suggests that many of us should care a bit less about our careers and reputations and a bit more about our work. His story recommends

humility when some of us confidently assume that we know well the recent history of photography, that we know who's who and exactly what's been done in photography. His photographs remind us that descriptive photographs can gather extra meaning and importance as time goes by. Although Stochl never intended to document downtown Chicago, his images have, over time, become a wonderful, important historical resource for the city.

Finally, I hope Gary Stochl's story will teach us that great work can eventually find the audience it deserves. I have enormous respect for Gary Stochl's photographs and perhaps even greater respect for Gary himself. We at Columbia College Chicago feel privileged to have played a small role in bringing the work of this exceptional photographer out into the light.

ON CITY STREETS

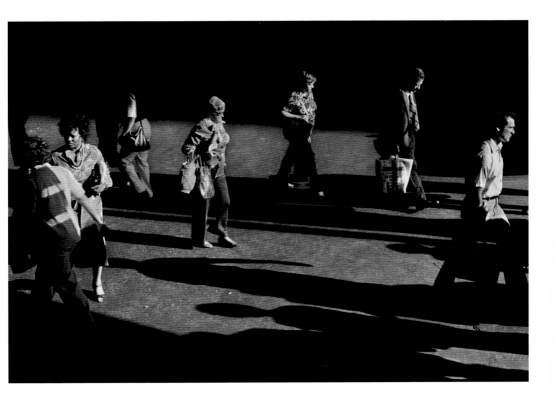

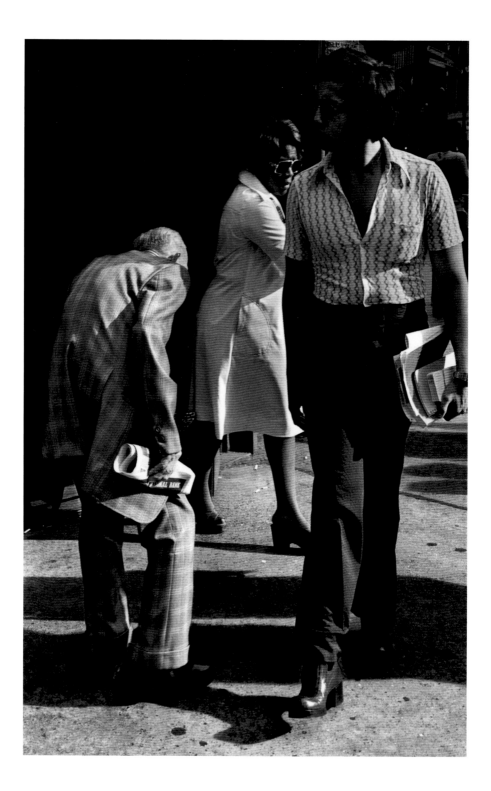

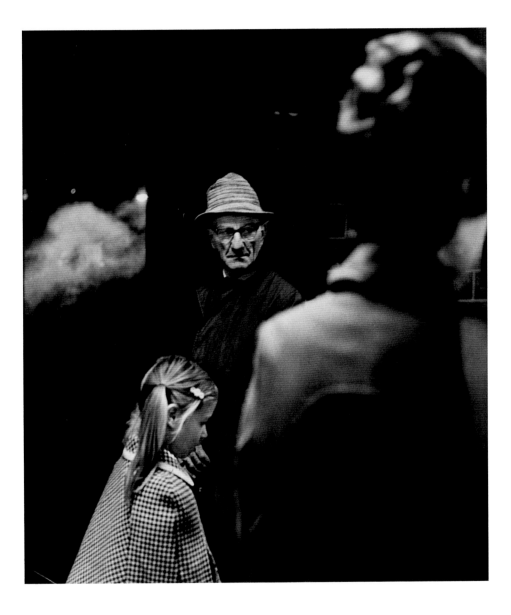

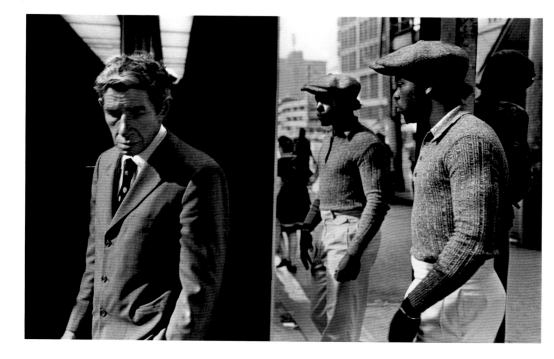

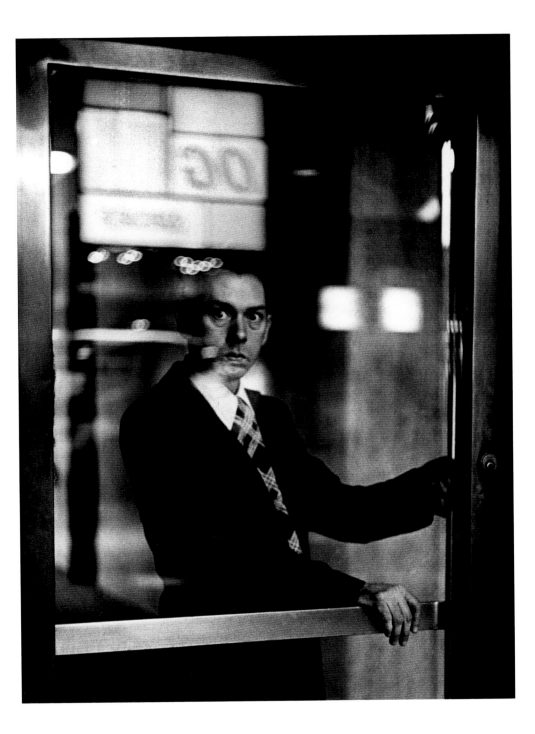

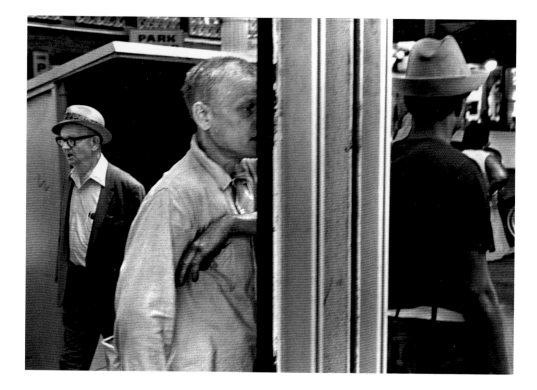

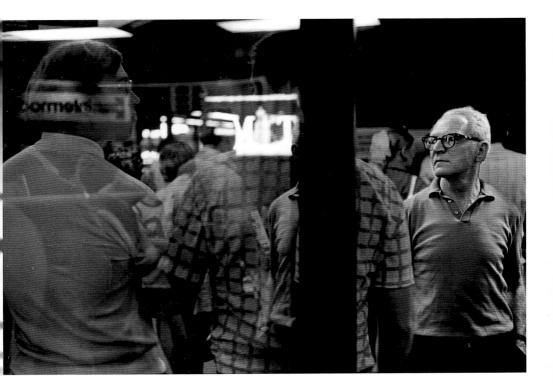

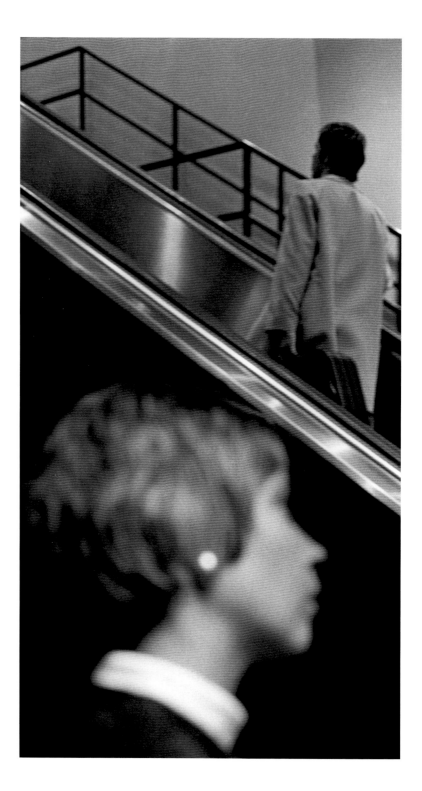

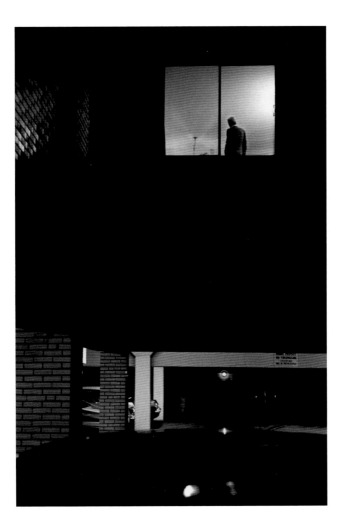

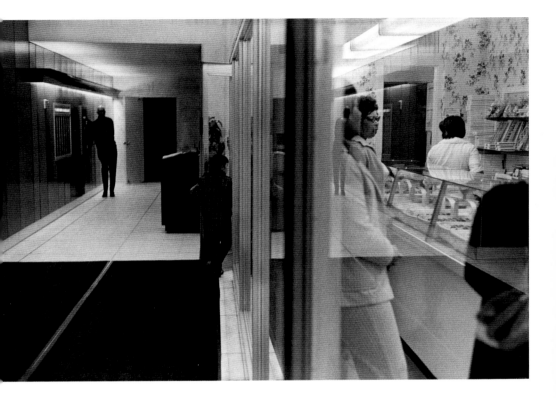

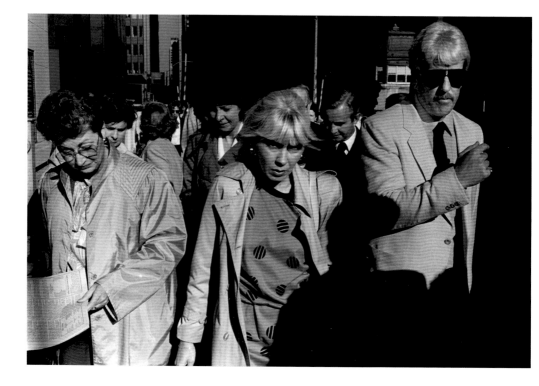

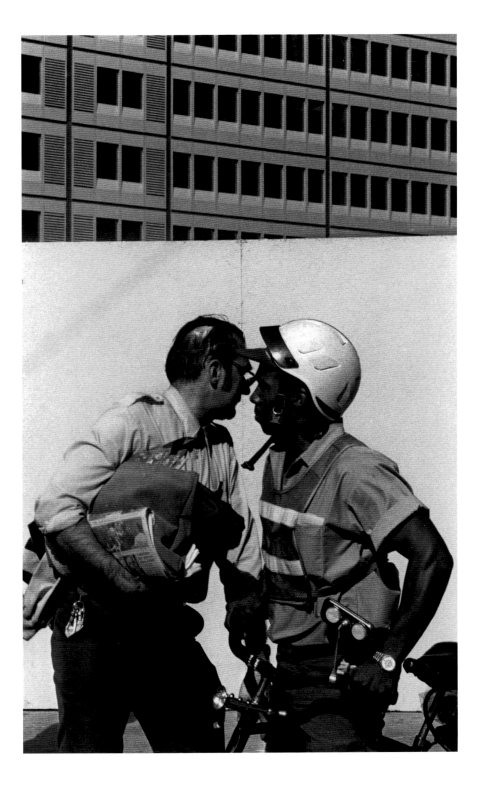

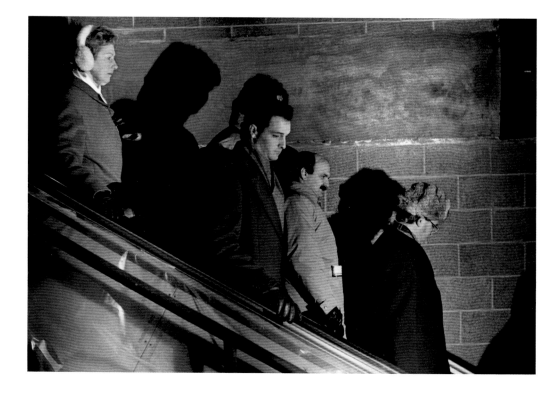

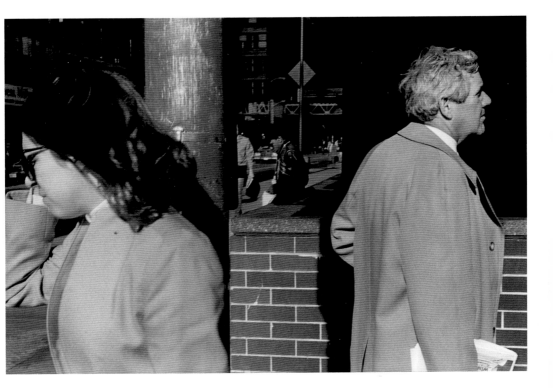

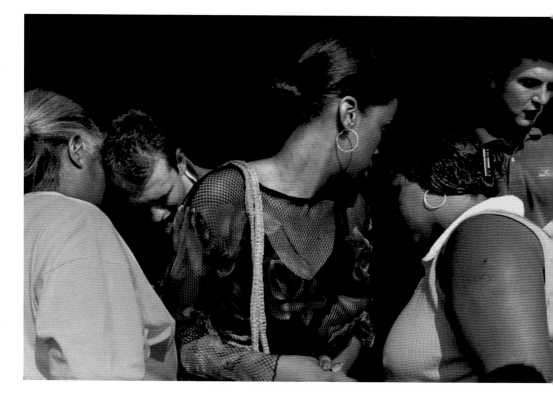

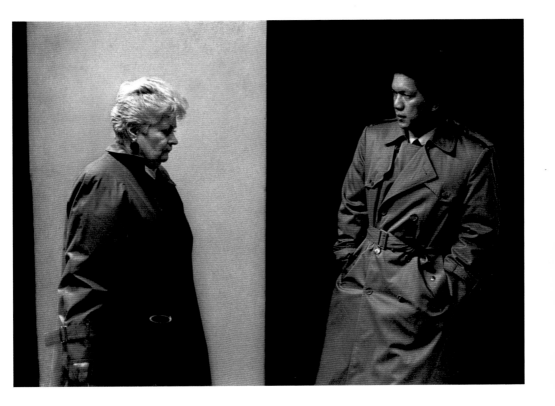

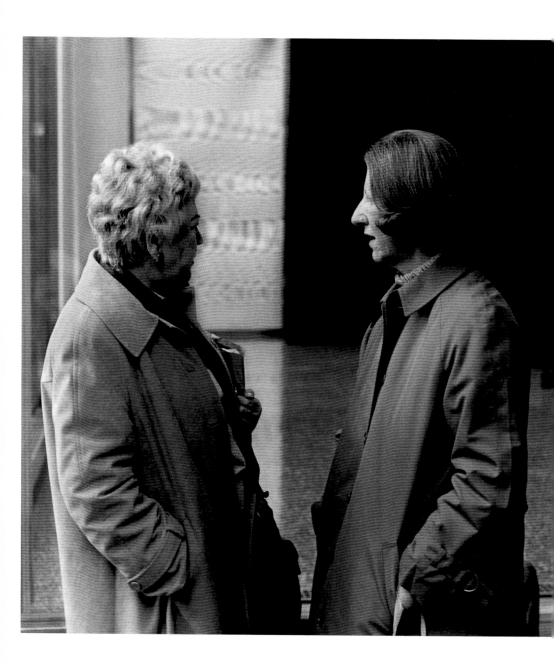

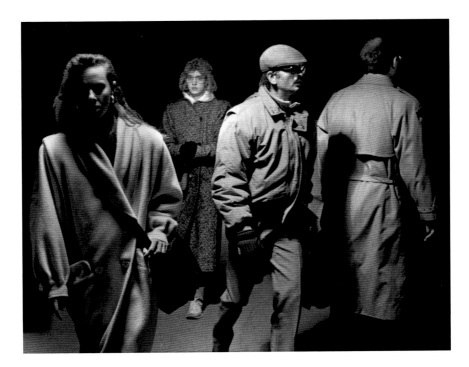

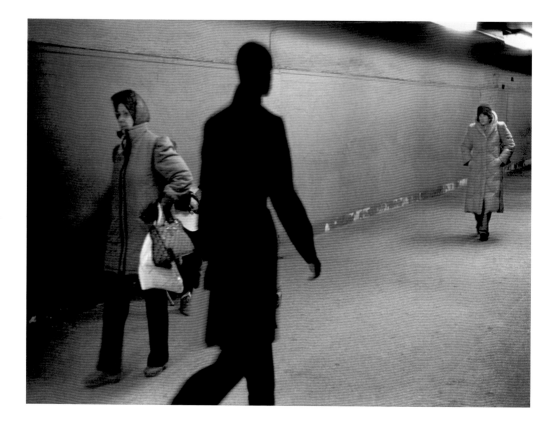

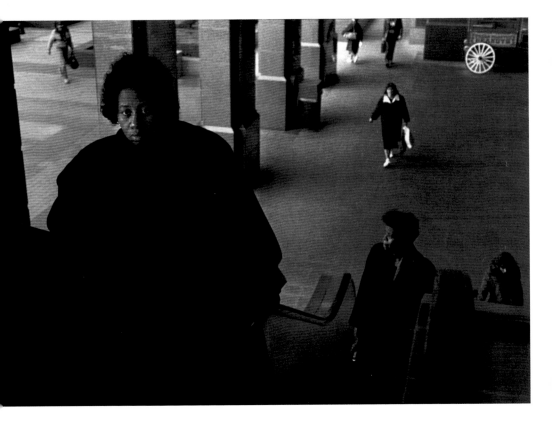

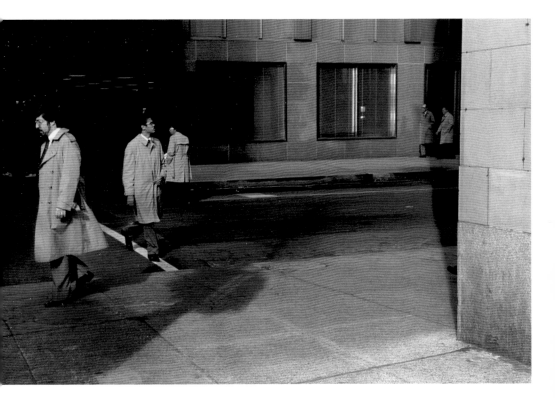

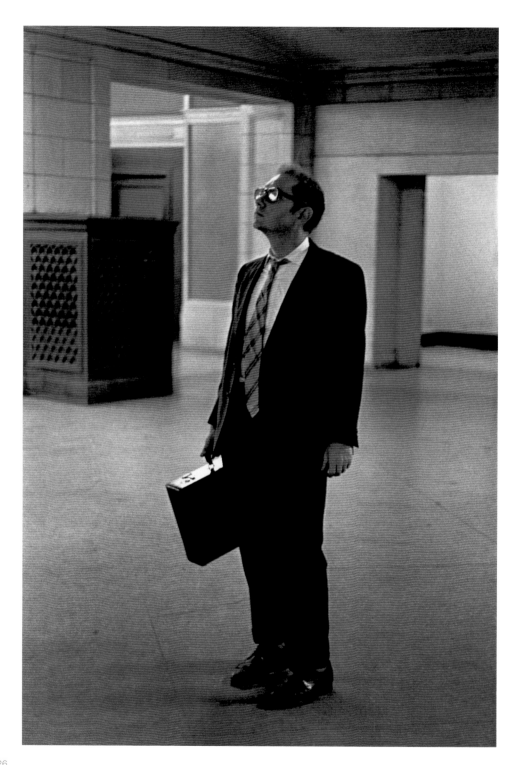

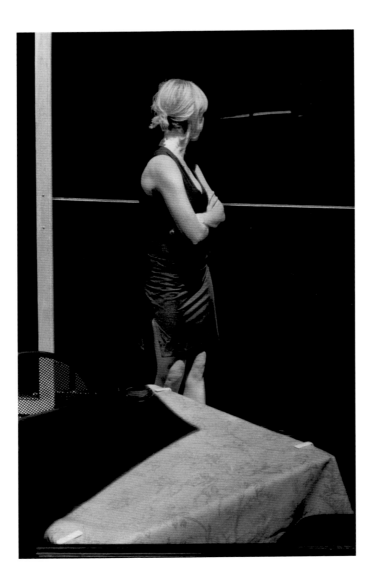

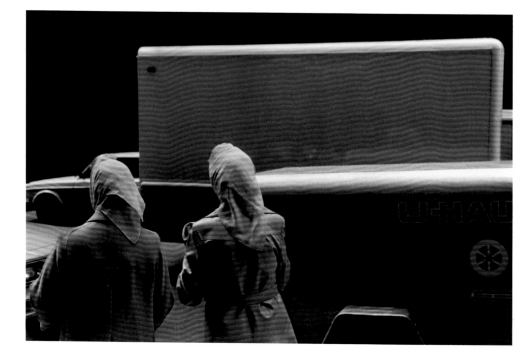

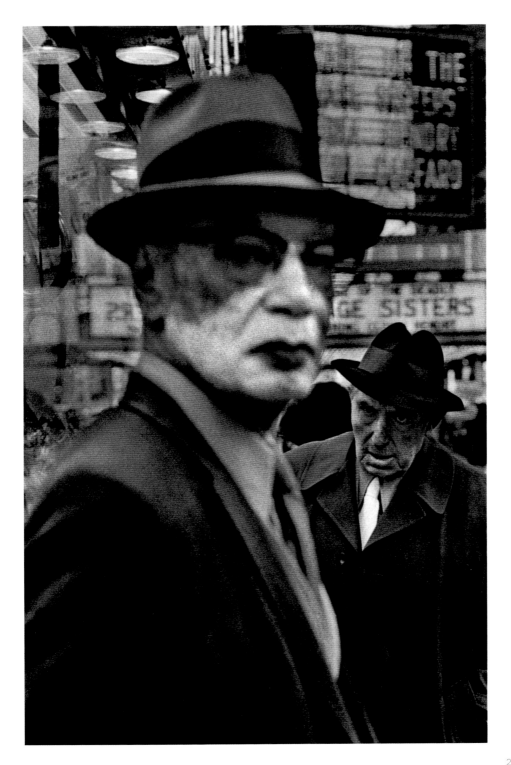

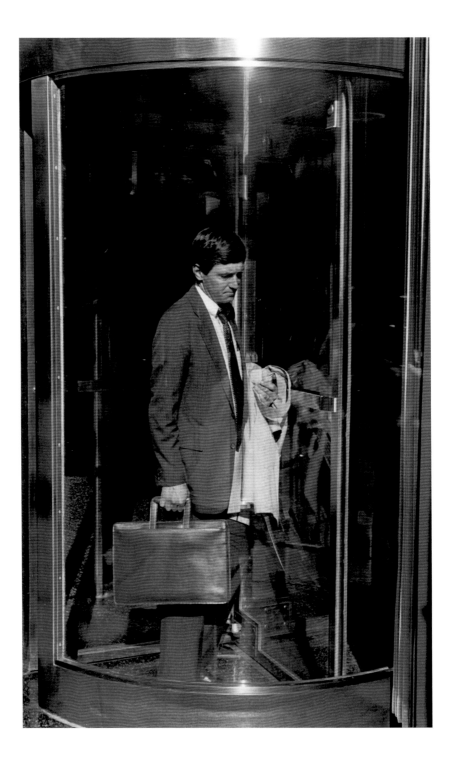

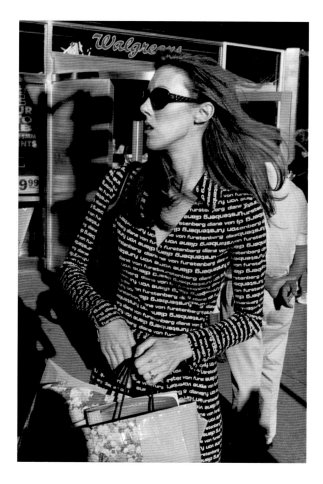

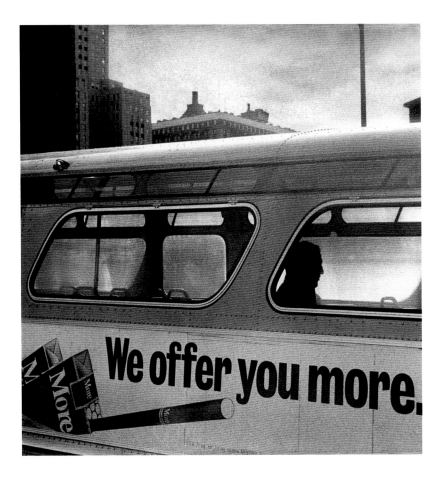

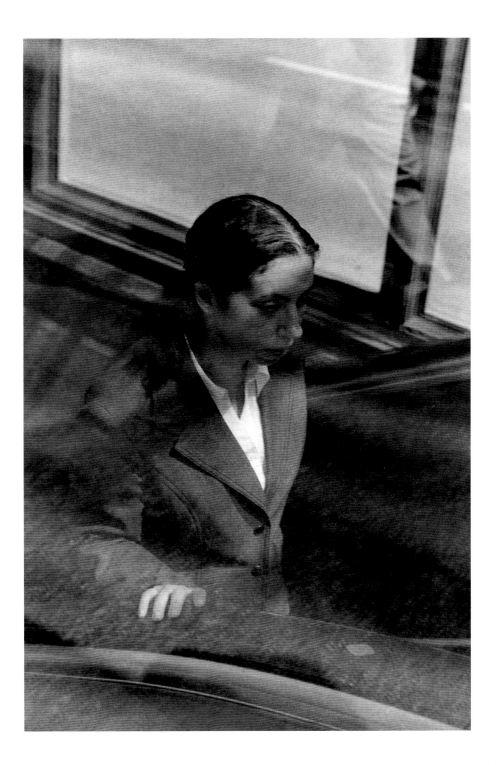

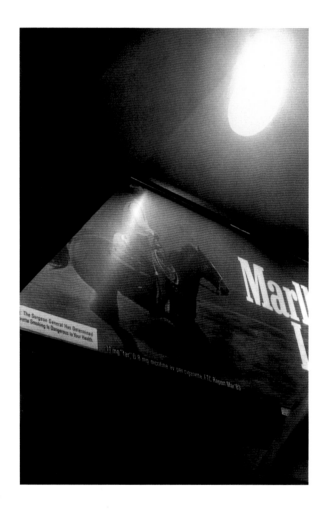

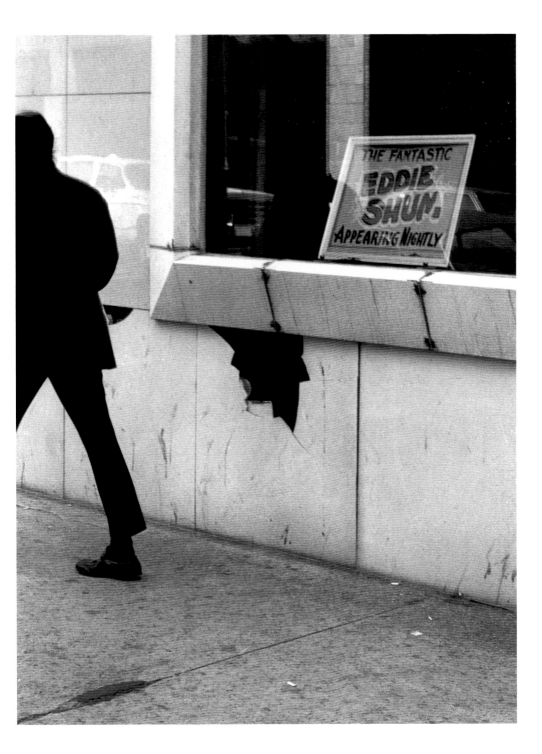

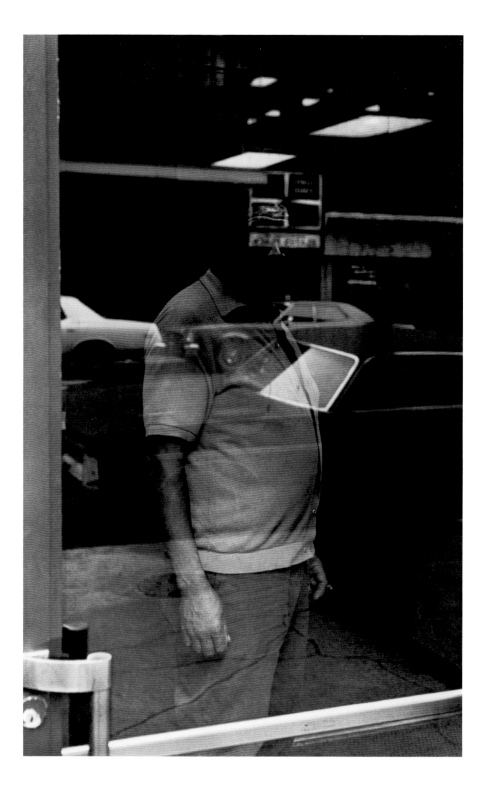

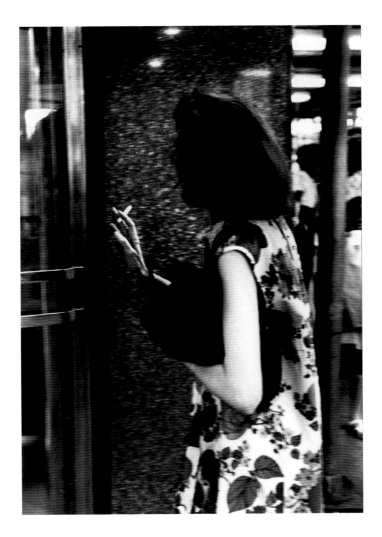

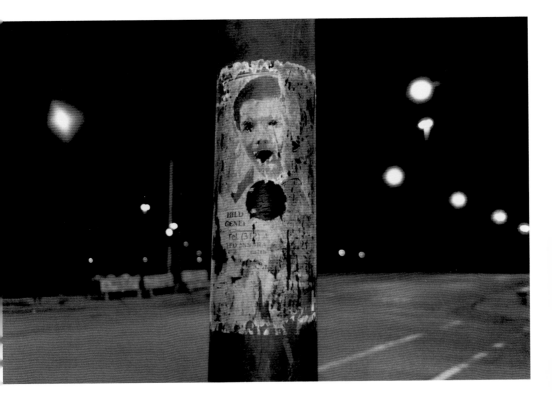

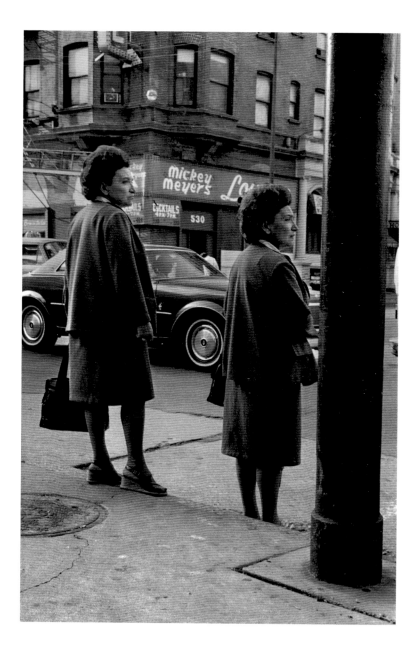

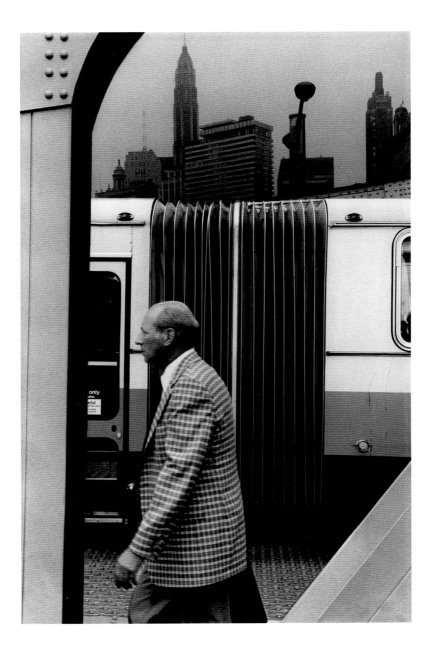

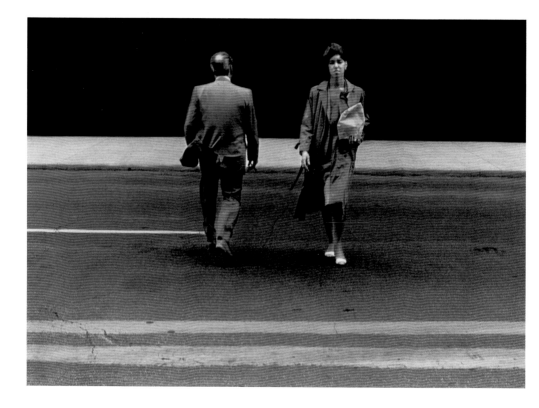

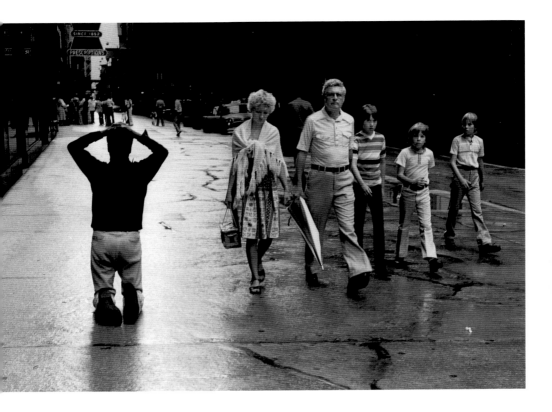

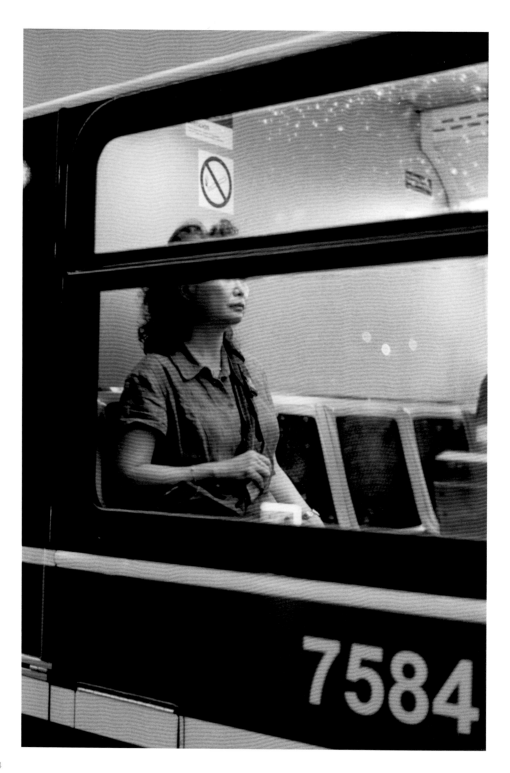

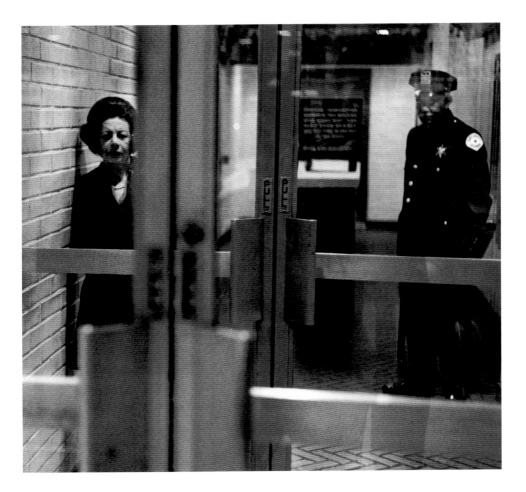

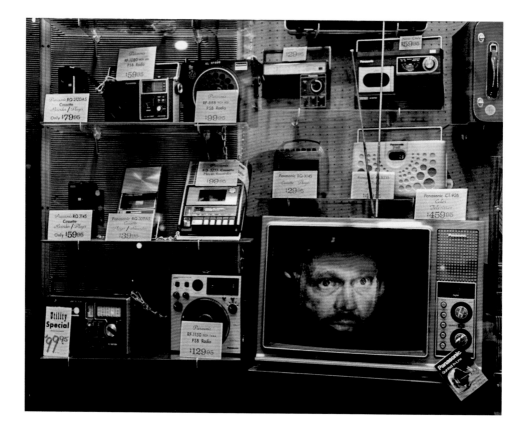

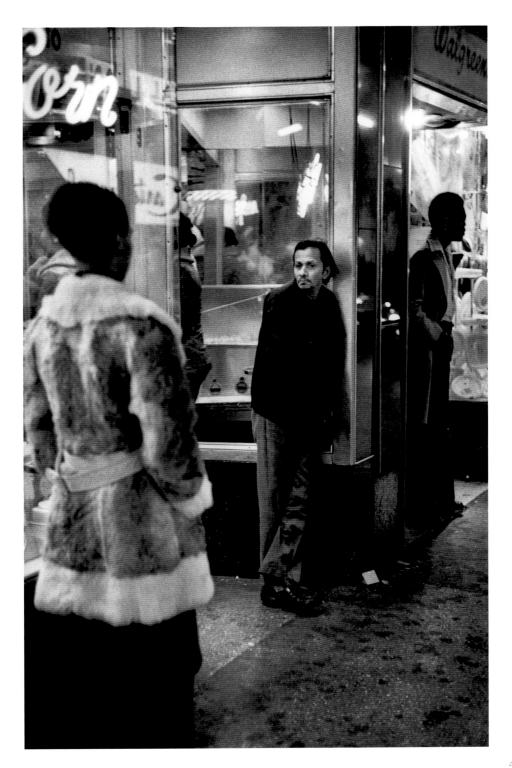

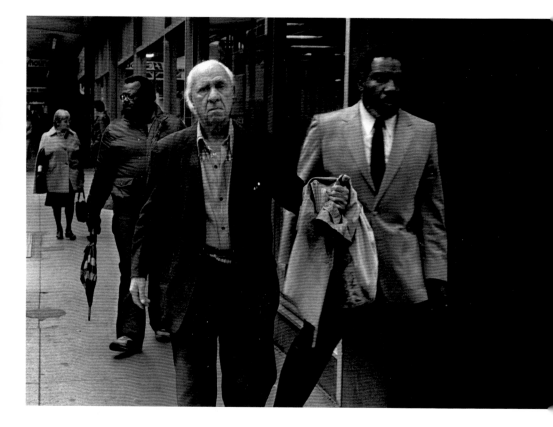

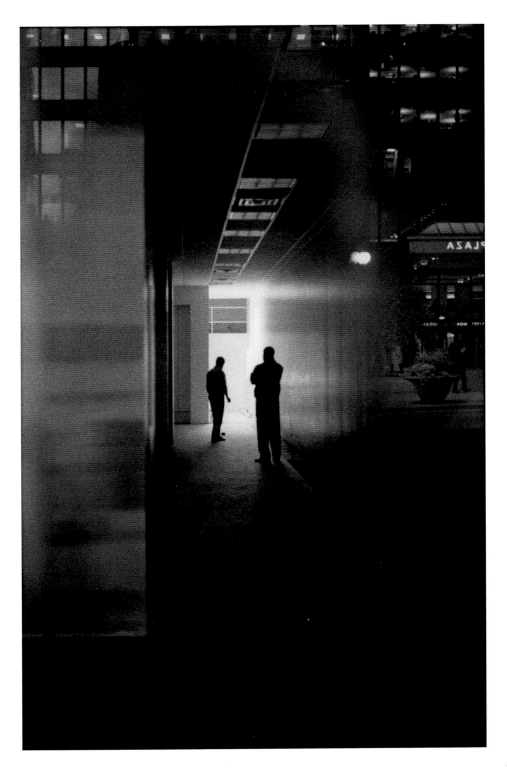

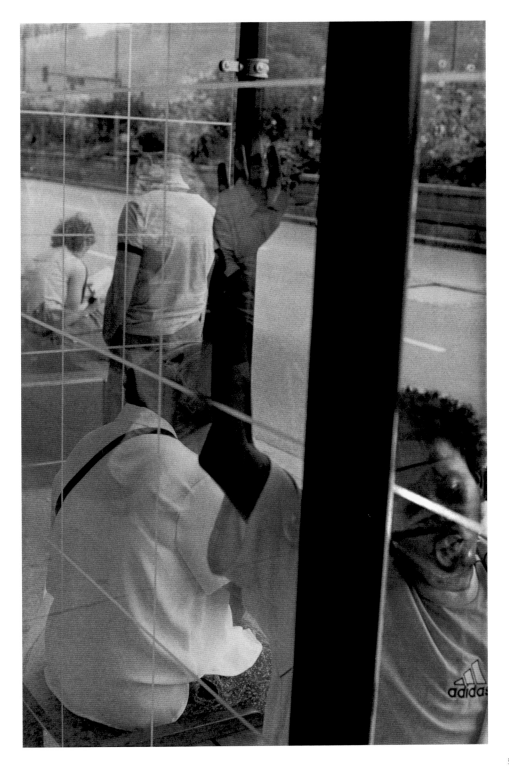

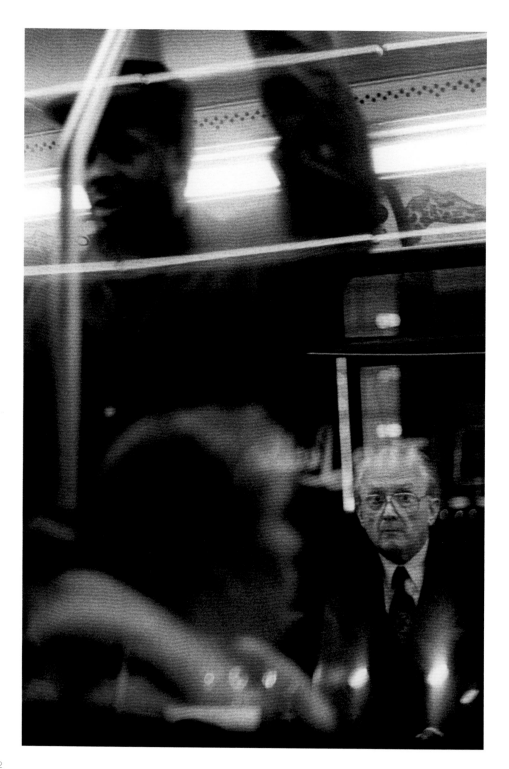

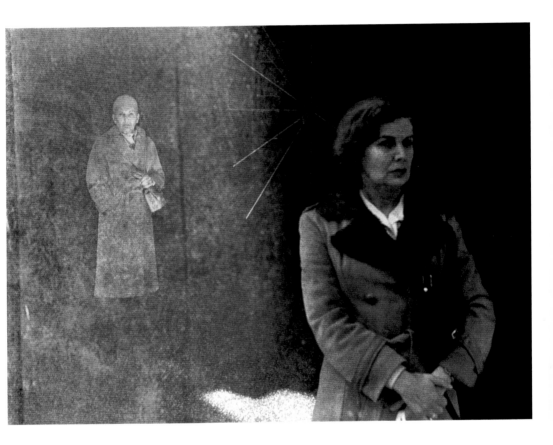

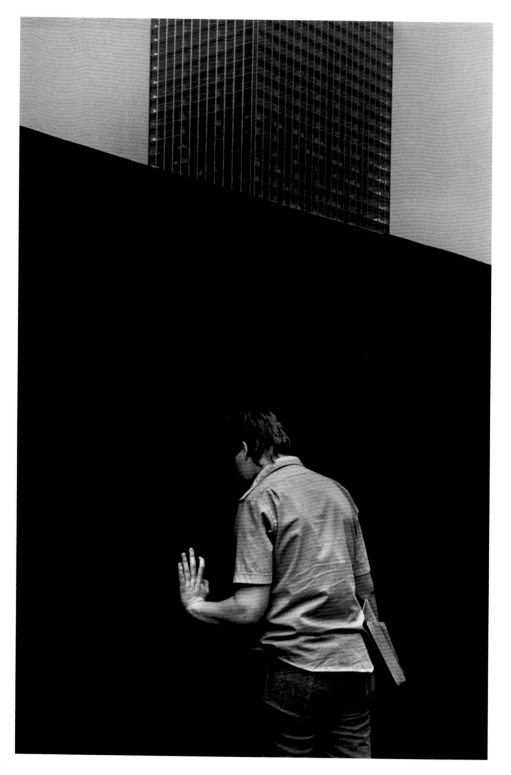

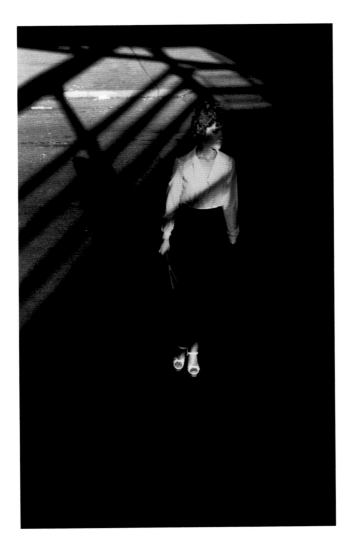

LIST OF PLATES

ACKNOWLEDGMENTS

I would like to thank the many people who have generously supported me and my work over the past year. I wish I could list them all. Ken Hirte, the owner and director of Gallery Chicago, was among the first to see and exhibit these photographs. I'm grateful for the support and efforts of my dealer, Shashi Caudill, and for the support of David Travis, Liz Siegel, and Kate Bussard at the Art Institute of Chicago. Many thanks to Gregory Knight, Lanny Silverman, and others at the Chicago Cultural Center for offering an exciting opportunity to exhibit these photographs, and for all the hard work involved with that show. I thank Bob Thall, chairman of the Photography Department at Columbia College Chicago, who contributed an interesting introduction to the book and whose early support was crucial in launching this project.

This book required the essential participation of many people. Jeanne and Richard S. Press provided generous support for the book. I'm grateful to George F. Thompson, president and publisher of the Center for American Places, and his colleagues in Staunton, Virginia, and Santa Fe, New Mexico. I thank all the people at Columbia College Chicago who made this book possible: Colleen Plumb contributed a sensitive and elegant book

design; Ben Gest produced highly accomplished digital scans of the photographs; and Christine DiThomas provided excellent copyediting. I also thank Dr. Warrick Carter, President of Columbia College Chicago, Steven Kapelke, Provost, Leonard Lehrer, Dean of the School of Fine and Performing Arts, and Michael DeSalle, Chief Financial Officer. Tom Shirley, John Geiger, Creo Americas, Inc., and Columbia's Digital Lab staff made the prepress work possible. Finally, I extend special thanks to Steini Torfason and all of the others at Oddi Printing in Iceland for their great press work on my book.

ABOUT THE AUTHOR AND THE ESSAYIST

GARY STOCHL was born in 1947 in Chicago and was raised in Stickney, Illinois, where he still resides. He discovered painting, drawing, and photography in 1964, while in high school. Stochl photographed in the New York City metropolitan area and in Korea while serving in the Army. Except for those years in the service, he has continuously photographed in Chicago and its environs. Stochl's photographs were first publicly seen in a Fall 2003 exhibit at Gallery Chicago. He had a one-person exhibit at the Chicago Cultural Center in 2005. His photographs are in the permanent collection of the Art Institute of Chicago, the LaSalle Bank Photography Collection, and numerous private collections.

BOB THALL is a professor of photography and chairman of the Photography Department at Columbia College Chicago. His books of photography include *The Perfect City* (Johns Hopkins, 1994), *The New American Village* (Johns Hopkins, 1998), *City Spaces: Photographs of Chicago Alleys* (Center for American Places, 2002), and *At the City's Edge: Photographs of Chicago's Lakefront* (Center for American Places, 2005). His photographs are in the permanent collections of the Art Institute of Chicago, the Canadian Centre for Architecture in Montreal, the Getty Center for the History of Art and the Humanities in Los Angeles, the Library of Congress in Washington, D.C., the Museum of Contemporary Photography in Chicago, the Museum of Fine Arts in Houston, and the Museum of Modern Art in New York City, among others.

The Center for American Places is a tax-exempt 501(c)(3) nonprofit organization, founded in 1990, whose educational mission is to enhance the public's understanding of, appreciation for, and affection for the natural and built environment. Underpinning this mission is the belief that books provide an indispensable foundation for comprehending and caring for the places where we live, work, and explore. Books live. Books endure. Books make a difference. Books are gifts to civilization.

With offices in Santa Fe, New Mexico, and Staunton, Virginia, Center editors bring to publication 20–25 books per year under the Center's own imprint or in association with publishing partners. The Center is also engaged in numerous other programs that emphasize the interpretation of place through art, literature, scholarship, exhibitions, and field research. The Center's Cotton Mather Library in Arthur, Nebraska, its Martha A. Strawn Photographic Library in Davidson, North Carolina, and a ten-acre reserve along the Santa Fe River in Florida are available as retreats upon request. The Center is also affiliated with the Rocky Mountain Land Library in Colorado.

The Center strives every day to make a difference through books, research, and education. For more information, please send inquiries to P.O. Box 23225, Santa Fe, NM 87502, U.S.A., or visit the Center's Website (www.americanplaces.org).